May you find awe and wonder every day Love, mom

A Wonder Journal

Fifty Years of Awe and Audacity

Illustrated Poems and Stories
by Nancy Herrell Lockwood

Koinonia Associates, LLC
Knoxville TN

ISBN 978-1-60658-021-9

Published by:
Koinonia Associates
7809 Timber Glow Trail
Knoxville, TN 37938

To learn how you can become a published author, visit
PublishwithKA.com
June 10, 2011

Illustrations by Nancy Herrell Lockwood

Dedication

I dedicate this book to my large extended family. So many of them lit my path during this journey. I pray also that children of all ages will find in these pages new reasons to laugh and look with awe and wonder on all that we share on this planet.

Acknowledgement

I am grateful to have had parents who taught me to trust Jesus who modeled for their children life lessons that carried us safely through the decades. Thanks to those who loved the drawings and paintings, especially the Critters, and encouraged me to write their stories. Most of all I am grateful to God for giving us such an inspirational world.

Foreword

Drawing and painting comes naturally to most children and I never did grow up. Over the years the skill brought jobs, satisfaction and occasionally, escape, during difficult days. Many of the poems and stories helped tell how I came to a place of comfort and joy even in the sad or hard times. The stories are the Critter's own tales. The underlying message in each story and poem is a sense of gratitude for each of life's experiences.

Table of Contents

Nature's Wonders

Childhood Only for Children

Family & Friends

I Wonder

Found

Aging Gratefully

Li'l Critters - A Gift from God

I have been drawing and painting for as long as I can remember. But the Li'l Critters came to live with me while my children were toddlers in the mid sixties. I wanted to develop a caricature that I could market at local arts and crafts shows. Beginning with drawings of realistic mice, then paring away some of the rodent features, the Critters emerged. I think God gave them to me knowing I would need their encouragement and companionship through the years. Our adventures have included escape from reality at times. It has always been fun working with them. Imagining those critters as children, I could have them do anything I wished. They would behave as I thought children should.

Large watercolors which needed huge blocks of time had to be laid aside when the children were small, but the Critters were perfect subjects. I'd sketch them in pencil on watercolor paper, draw the details in ink with my fine tipped technical pen, erase the pencil lines then watercolor the drawing. At any point I could lay the work aside and attend to the children. The paints in my palette might dry, but they were, after all, watercolors, quickly restored with water.

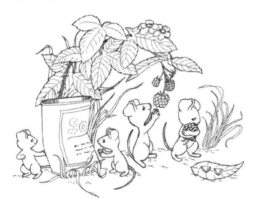

Being active in a Craft Guild gave me a small income and friendships with other artists and craftsmen. One day at a show while water coloring a Critter drawing I overheard a woman remark to her companion, "That doesn't look very difficult, all you have to do is stay in the lines." The first Critters sold for as little as four dollars and small cards for twenty-five or fifty cents. They were sold in east Tennessee shops, shows and galleries. Two trips to California, were financed by sales of the Critters in a friend's Mendocino gallery. We made lots of friends in California.

As I looked at all the ways the Critters had helped me through the years I began to see how much they were truly a gift from God, my own dear friends.

They were cheerful, rarely sad, never disrespectful or disobedient, perfect "children in disguise." The Critters would never grow up and leave home. When I was sad or discouraged they took me for a time into their imaginary world and we'd laugh and play for awhile. We've been having exciting adventures for nearly half a century.

When my first marriage failed and I needed to find work to support my two children, the Critters helped me find the perfect job. A research laboratory advertised for someone who was proficient in ink drawing. Their primary research animals were, guess what? Mice! Of course, I had several mice drawings in my portfolio. We did mostly graphs and charts for scientific meetings and publications, but

when they needed a mouse drawing there was a Critter specialist on staff!

The Critters and I made friends with hundreds of people in those decades. When I met the man who would become my new husband he said he was already familiar with my friends, having seen paintings of them in the homes of different family members. Critters have traveled to many countries as paintings and note cards.

From the beginning the Critters seemed to tell their own stories. People would ask for the story behind a painting and all I could say was that the activities of the mouse or group of mice invited you to imagine the tale. It took several years for me to find just the right Critter words for their stories.

When husband Bob was enrolled in seminary in Memphis I applied for a job at the denomination's publishing house with the drawings and stories of the Critters in my portfolio. They didn't hire me for another two years, but printed several of the stories and poems in the denomination's magazine. I also illustrated stories and poems Bob submitted. See how the Critters kept on helping through the years.

Although a house and monthly salary went with Bob's first job as an assistant pastor, medical bills for several eye surgeries for me took all our savings and we were nearly broke. We questioned if Bob should continue his seminary education.

His brother and sister-in-law sent money, calling it an advance on a booklet for the Crosseyed Cricket, their business in Lenoir City, Tennessee.

The surgeries and continuing visual problems had taken the vision in my right eye. And a cataract was developing in the left. I had to work very close to the art work, so I took a couple of inches off my brush handles to avoid damage to the left eye. Jim and Jean had faith I'd be able to write and illustrate the booklet regardless of the problems. The job was completed within the year!

Included in the booklet were drawings of the animals at the Cricket, more Critters (the gift kept on giving).

During the last year of our Memphis stay I was hired by the publishing house as their office manager and proof reader. More stories and poems were published (I think I was the only one-eyed-proof-reader in the field).

Over the years I sold larger watercolors, mostly birds and animals, ink drawings of owls called "Hooties," and ink and watercolor birds called "Bitty birds," but the Critters were everyone's favorites.

Newsletters printed for family with photos and prints began in 1989; a chronicle of family events with poems and tales with lots of illustrations including Critters.

Over one hundred of the laminated prints are being used as "Hands-On-Art-shows" for health care and assisted living facilities. We pass the prints around while I tell stories about the paintings and my journey. No one has to

worry about harming a painting and all of us have a good time laughing about the antics of the birds and Critters. Included in the collection are ink drawings of my father's family home place. The seniors enjoy the old buildings that remind them of their own family history and farms of their childhood.

Declining vision was not a surprise.

A specialist informed me in 1974 that I should plan to do all I wanted to do in the next few years because my particular problem might cause blindness within fifteen years. Several eye surgeries later I did lose the vision in my right eye, but I consider every day after 1989, the fifteen-year deadline, a blessing.

Many of the ink drawings stored on my computer can be printed on watercolor paper then painted. Though I find detail work very difficult now, I still print personal note cards, family newsletters and booklets of poems or stories using the file of drawings and paintings.

Besides entertaining me each time we created a new image, the Critters have helped me through the personal challenges, tragedies and medical problems. I thank God for those happy "Children in Disguise.

God is good, all the time!

Grampa's Critter Stories

My name is Ben, the same as my Grampa, Benjamin Wise. He's my best friend. We made a bargain when I was very young. When he talks, I listen, and when I talk, Grampa listens. He is the only grown up I know who listens to me all the time.

We do fun things together. My favorite times are those we spend walking in the woods while Grampa tells me about the plants and animals. He knows all their names and where to find them. Since I've gotten older, I don't have to ask the names of many of the plants. I can sit silently so birds and animals forget that I'm there. You can see and hear a lot more if you're still and quiet.

Grampa answers a question sometimes by telling an animal story. He calls them critters. The stories are easy for me to understand and I can remember the lesson when it is about someone else. Once he told me that these kind of stories are sometimes called parables. I heard about parables in church. Jesus taught with parables. Last week Grampa told me a story about Molly Mockingbird.

Molly Mockingbird

No one had seen Molly Mockingbird for several days. The forest just wasn't the same, almost sad, without her lovely music. Other birds still sang, but Molly's music was unusual because she sang so many different songs. It was always special when Molly sang.

"Wouldn't it be terrible if we never heard her again," said Rick Raccoon. "I think we need to tell her how much we miss her. We never told her that her music makes this a great place to live. She might like to hear that."

"Let's have a party," said Chipper Chipmunk bouncing up and down. Everyone else thought that was a great idea and began collecting seeds and berries, lots of juicy blackberries which Molly liked so much.

Soon they had enough goodies for a party. As quietly as little critters can, they tiptoed up to Molly's tree hoping to surprise her.

As hard as they tried, they could no longer be quiet. The critters were so excited that they began to chant, "Molly, Molly, Molly..."

Of course, Molly was startled to hear such a racket. She peeked from under a leafy branch and asked in a hoarse whisper, "What's wrong, is someone hurt?"

Flying up to Molly's perch, Wendy Wren said, "We've been missing you and your beautiful songs, why did you stop singing?"

"Well, I've had a sore throat and lost my voice, but I'm much better now," croaked Molly. "You can't know how much this means to me. I didn't know anyone listened when I sang."

The party lasted till the sun had dropped below the trees. All the woodland critters had a great time, especially Molly.

In a few days she was singing again, better than ever. Never again would she wonder if she should sing. Each animal and bird would pause to listen and smile, remembering when it was much too quiet in the woods.

I waited a few seconds, until I knew that Grampa had come to the end of the story, so we could talk about it. "Is that a parable, Grampa?"

"What do you think, Ben?" (My Grampa asks that question a lot.)

"Well, I think it must be important to tell people how much we appreciate the special things they do for us," I said, grinning. "Is that what the parable means?"

"What do you think?' said Grampa, grinning back at me.

That's a funny thing, we have the very same lopsided grin, everyone says so. Mom says no one will wonder if we belong to the same family.

After the mockingbird story, I sneaked up behind my mother, gave her a big hug and thanked her for such good meals, for playing games with me, and all the other neat ways she makes me happy.

When she asked why I had hugged her, I told her, "Oh, it's just something I learned from a little bird."

And be kind to one another, tenderhearted, forgiving one another, just as God in Christ also forgave you. - Ephesians 4:32

Foxy Finds The Real Treasure

Anyone could see that Foxy was upset and very jumpy, running here and there, looking under every bush, around every bend in the forest path. Something was very wrong, but Caroline couldn't imagine what it was. Foxy wouldn't talk to her. He just mumbled to himself and turned a different way every time she tried to get his attention.

Finally, Caroline flew right down in Foxy's face and flapped her tiny wings on his nose, "Stop just a minute and tell me what's wrong, maybe I can help."

"Don't bother me now," Foxy muttered, "I've got more important things to do than listen to a little bitty bird. I can do it myself, I lost it, and I have to find it. Besides, what help could you be?"

Caroline didn't let his rudeness bother her, she knew he was upset and worried and not his usual, friendly self. "You never can tell what little folks can

do. What did you lose?" She was using her best manners to get Foxy to listen.

Now Foxy was sorry he'd been so short tempered with his friend, so he stopped and sat down watching the tiny brown bird flying around his head. "It's my shiny black stone, I can't find it anywhere. I carry it around in my mouth," said Foxy almost in tears.

"When do you remember having it last? Two of us might be able to find it faster."

All of a sudden Foxy was angry again, "What makes you think a silly, little girl bird, can find something I can't?" Caroline knew it was the worry talking. Foxy was usually easy-going and polite to everyone. Although he had been rude, Caroline flew away to hunt for Foxx's special stone. He did not want to take any advice or help from her, but she would help, or her name wasn't Caroline Anne Wren!

20

Caroline covered a lot of space flying in wider and wider circles. Foxy was zipping around with his nose to the ground, searching again and again in the same places. He didn't even notice Caroline overhead.

After an hour of careful searching, Caroline flew over a hill and spotted Foxy' stone shining in the sun. It was on a stump in the topmost spot of the meadow. She thought for a second that she wouldn't tell that rude Foxy about her find, but only for a second, then she flew off in search of her friend. When she found Foxy, she flapped her wings and sang as loud as she could. Wrens can sing very loud.

Poor Foxy wasn't in any mood for music, but he stopped dead in his tracks with the same angry frown he'd had on his face before. He didn't get a chance to say a word, though. Caroline began pouring out her news so fast that Foxy almost missed what she was saying.

"I found it, I found it on Laurel Hill," Caroline said, all in a rush.

Then Foxy remembered that he had been on the stump earlier that morning when Timmy Turtle wanted to play. "But how did you find it? I have been looking all over the woods. I'm bigger, and I have a good nose, and I looked longer, all morning. How could you be smarter than me?" he wondered out loud.

"You were looking on the ground, and since it was on the stump, you never would have found it. Did you know you were zigzagging all over and over the same places?" Caroline was trying to be kind, but Foxy was puzzled.

"Didn't you know that although I am smaller, I can do things you can't, like fly? Big isn't everything you know. I can see things you can't from the air, and I can fly almost as fast as you can run. You are bigger and stronger, so let's go get it. I couldn't carry your stone."

The two of them raced to Laurel Hill and there it was. "Thanks," Foxy whispered. "I was so rude to you. I don't think that I would have bothered to help if you had been that rude to me. I'm so sorry."

"I wanted to help, besides you needed to find out that two different critters can make a good team for getting a job done. When I need to find something smelly, I'll call on you. My nose isn't as good as yours," Caroline giggled.

Now Foxy was laughing too. "And when I want music, I'll call on you, my singing is pretty sad."

After that day Foxy took the time to think before saying hurtful words, and most of the time it worked. He needed to say, "I'm sorry," less and less. Caroline and Foxy became even better friends after their day of searching. Weeks later Foxy gave his smooth black stone to Rick Raccoon for his rock collection.

The old treasure wasn't as important to Foxy anymore. He had risked losing a more valuable treasure than a little black stone. Foxy now knew a better treasure was good friends.

These things I command you,
that you love one another.
- John 15:17

22

Do Not Be Afraid

Of all the birds in the forest, Belle was the most timid. Those chicks hatched the same season as she, were already flying through the forest and over the fields, But Belle was afraid; she might fall, she might get lost, she might be snared in a net or caught by a cat. It was dangerous. All these excuses kept her from trying to fly.

Gramma Anna Belle came for a visit the summer after Belle was hatched. She didn't expect to have much time with her namesake because young birds enjoy flyubg and playing games with their brothers and sisters and friends. But there in the hollow tree was Belle, still afraid of everything. Well, Gramma got to work.

She talked Belle out on a limb beside her. "You know I used to be afraid to fly too," the older bird confessed.

"Really, Gramma?" asked Belle anxiously looking at the ground below.

"Yes, Belle, I was afraid, but I got over it."

"How?" asked the frightened youngster.

"Well, a wise old bird helped me learn that being afraid to try was keeping me from a lot of fun and many new friends. My grandmother helped me out on a limb over a

pile of pine needles and told me that if I fell, the soft landing wouldn't hurt. I teetered on that limb with my grandmother while she said things like:"

"You can do it if you don't look at the ground."

"You were made to fly, just step off, don't look down and flap your wings."

"I'll fly with you all the way, I won't let you get hurt."

23

"And," grinned Gramma, "I did, and it was easy, and it was fun, and I have been flying ever since. It was exactly like my grandmother said, "I was born to fly. After that I wasn't afraid to try anything. It's great fun to fly through the woods and glide high above the trees.

"I know you are afraid, just as I was, but you can do it, I know you can. Just flap your wings really fast."

"OK, Gramma, I can do it, if you can," and she stepped off.

"Oh, no, the ground is coming closer," cried Belle.

"Faster, Belle, faster, you can do it," encouraged Gramma.

"I can fly, I can fly," yelled Belle, climbing higher and higher. She was no longer afraid. It was like floating up there above everything.

She's been flying ever since. You see she was born to fly.

For God has not given us a spirit of fear, but of power and of love and of a sound mind.
 - 2 Timothy 1:7

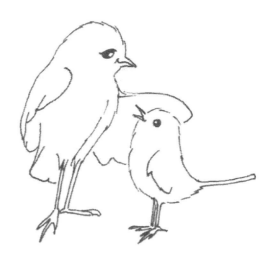

Family Ties

Ben lay in his room awake, but with his eyes shut tight. This was the saddest day ever. Not even the singing mockingbird outside his window could cheer him up. Grampa was leaving today for a long visit with Aunt Sarah. Thinking of how empty his days would be without Grampa a tear squeezed from under his eyelids.

Wiping his face, Ben got out of bed, dressed, and shuffled slowly into the kitchen. He and his grandfather had planned a special meal, just the two of them.

"Good morning, Ben, do you want to peel the eggs while I make the toast?"

Ben nodded his head and ran cold water over the pan of boiled eggs. He found a teaspoon in the top drawer, cracked the egg shell all over with the

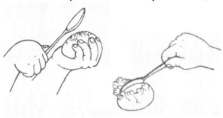

back of the spoon, and began peeling the shell from the warm egg. By sliding the spoon under the cracked shell Ben was able to finish in no time. Soon he and Grampa were seated at the breakfast table ready for the blessing.

Halfway through the silent meal, Ben began talking about what was on his mind. "Grampa, do you hafta go? I'm afraid you won't come back or you'll forget all about me."

"No, no, Ben, I'm just going for a visit with the rest of the family, your aunt and uncle and cousins. I'll be back before you know it. How could I forget you? Do you know that I think of you everytime I tie my shoes? You were the last one I taught, so I think of you each time I tie mine.

"That's kinda like when I peel an egg, I think of you. Mama doesn't do it that way, but we do, don't we?" Ben had forgotten his sadness while he and Grampa talked of all the things they did alike.

"That's a way for us to be together when we're apart," smiled Grampa. "Do you know who taught me how to peel and egg? My father did, and I suppose someone special taught him. We both have blue eyes and a lopsided smile, Did you know your dad's hair was the same color as yours when he was a boy? The way we look, the way we talk, and the way we act comes partly from our families and the people we're around most. It's hard to forget the ones you love when you think about that."

"Thank you, Grampa, I feel much better. You will think about me every day—as you tie your shoes. I will think about you when I do any of the things we like to do together."

Hugging Grampa very tight, he said, "Have a good trip and I'll write you. We'll have fun when you get back. I love you, Grampa."

"I love you too, Ben, you just don't know how much."

That night Mom found a verse in Philippians for Ben to read before he went to bed.

I thank my God upon every remembrance of you…
- Philippians 1:3

A Different Kind of Picnic

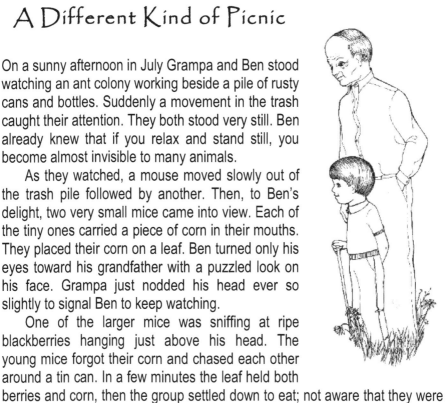

On a sunny afternoon in July Grampa and Ben stood watching an ant colony working beside a pile of rusty cans and bottles. Suddenly a movement in the trash caught their attention. They both stood very still. Ben already knew that if you relax and stand still, you become almost invisible to many animals.

As they watched, a mouse moved slowly out of the trash pile followed by another. Then, to Ben's delight, two very small mice came into view. Each of the tiny ones carried a piece of corn in their mouths. They placed their corn on a leaf. Ben turned only his eyes toward his grandfather with a puzzled look on his face. Grampa just nodded his head ever so slightly to signal Ben to keep watching.

One of the larger mice was sniffing at ripe blackberries hanging just above his head. The young mice forgot their corn and chased each other around a tin can. In a few minutes the leaf held both berries and corn, then the group settled down to eat; not aware that they were being watched.

When the mice finished their meal, Ben and Grampa crept off. Looking back, Ben thought he saw a mouse ballerina dancing in a daisy petal skirt. But

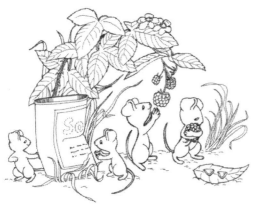

when he stopped and asked Grampa to look, all of the mice were gone.

"Did you see that, Grampa?"

"Just what did you see?" asked the old man smiling.

"Oh, Grampa, I saw a family of mice having a picnic just like we do," replied the excited boy. "But they didn't ask a blessing," he added,

laughing. "I also saw a ballerina, but all of them were gone when you turned around."

"Well, you know what I told you about the critters. When someone loves the outdoors and animals as we do and is willing to do the hard work of being absolutely still, he can see things others can't. This little poem says it best"

Fortunate are those who see
Flowers and critters
Instead of weeds and varmints
As they go by this way

"Let's go tell Mom!" Ben said tugging on his grandfather's sleeve.

"Well, Ben, that's the sad part of it. Not everyone sees animals and critters as we do. Many people don't believe that critters can do anything but eat crops and mess up kitchens." But Ben didn't wait, he ran into the kitchen and blurted out his news to his mother.

"Mom we saw a family of mice having a picnic, and I saw a ballerina mouse, but Grampa didn't see her."

"That's nice," said his mother still stirring the soup in her sauce pan. "Wash up for lunch."

"OK, Mom," replied Ben, looking sadly at his feet. As he slowly walked through the hall his grandfather joined him.

"Tell you what, Ben, let's just enjoy watching the birds and animals and hope other people can slow down enough someday to really see them."

"Alright, Grampa," whispered Ben, "but wouldn't it be grand if everyone could know that we humans are not the only ones that matter?"

Grampa later said, "look up Psalm 46:10."

The verse read:
Be still, and know that I am God…

28

Nature's
Wonders

Fortunate are those who see
Flowers and critters
Instead of weeds and varmints
As they go by this way

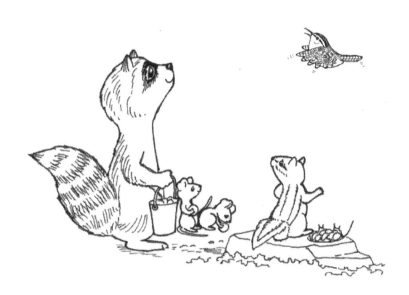

Spring Is Coming!

I walked the morning woods today
 To check on the progress of Spring.
Humming her customary tune,
 She hadn't yet started to sing.

Blossoming trees pastel and white,
 Challenged the early flowers,
The riot of color, not quite here;
 Awaiting more sun and showers.

While violets wash their faces,
 The willows comb their tresses.
Bluets and jonquils on parade,
 Azaleas still had no dresses.

One week the wood is dry and brown,
 The next, spring takes a chance.
Before you know it, she's full-dressed,
 Inviting her friends to dance.

Then all at once, the blossoms fade,
 And plants wear all green dresses.
We spot some color here and there,
 A hint of spring's excesses.

Each year within its cycle finds
 Days of delight in our wood.
Each season shares its blessings,
 God declares each one—good.

Prince of the Woods

Winter time finds birds of all kinds
 Crowding our feeder for seeds.
Some appear the same year-round,
 Others wear duller, seasonal weeds.

One frosty morning watching the crowd,
 I spied a nondescript fellow.
Could it be a favorite of mine,
 Unrecognized without yellow?

It was an incognito goldfinch!
 Going about his daily tasks.
The prince of the woods in my yard,
 What better sight could I ask.

Isn't it that way with those we meet?
 Shouldn't we always be kind and fair?
Mindful of our manner and words,
 Lest we entertain angels, unaware.

Sanctuary

Tennessee, O, Tennessee,
 Sheltered in your valley.
Were I not in Tennessee,
 Heaven's where you'd find me.

From a grove of ancient pines,
 I watched an eagle soar.
After such a vision bright,
 Should I ask for more?

Atop a mountain, near a brook,
 Signs of God around me,
Cradled in a mossy bed,
 I felt peace had found me.

Flowers scented sweet the air,
 Fruit and berries fed me.
Nature's sounds—a joyous hymn,
 Heaven's music led me.

Tennessee, O, Tennessee,
 Sheltered in your valley.
Were I not in Tennessee,
 Heaven's where you'd find me.

Under Our Noses

We went to the mountains for color.
 Still early for a bright array;
Green still dominated the hills,
 We'd not be back another day.

Rarely, bright orange appeared
 On the tips of a most-green tree,
But it wasn't what we had come for,
 Not quite bright enough for me.

The day was cool and beautiful,
 We enjoyed the mountain air.
"Oohed" and "aahed" over this and that,
 It was a good day, most fair.

At the end of our adventure,
 After traveling all that way,
There, in our own back yard, were
 The best colored leaves of the day.

At our age you'd think we'd know,
 But we learn again and again:
Look for beauty everywhere, but
 Treasure those gifts close at hand.

Sun Magic

One sunlit autumn day
 We walked mountain woods.
My sight slowly growing dim,
 Distant vistas were not good.

Sunlight hit a maple,
 Blazing like a lantern lit.
God arranged that vision bright,
 And hope grew, just a bit.

Now, at last, sight regained,
 I see with heart and eye.
Now I drink and savor all
 Contained in earth and sky

With one good eye I see.
 God's handiwork abounds.
Hungry am I to drink all in,
 Rejoice at sights and sounds.

I see scattered patches of sun
 Bright spots not there before,
Highlighting random leaves,
 While splashing the forest floor.

I pray that I always see
 By other senses, if not by sight.
"Seeing through a glass darkly"
 Is usually for need of "light."

Stop & Look & Listen

One day I was scurrying,
 Doing my routine chores,
I heard whispered—"Stop and look
 For what I have in store."

A little spring vignette
 Was there within my reach,
And as I took a breath,
 The Spirit began to teach.

"A time of new beginning
 Was planned with you in mind.
I prepared this special place
 Just for you to find.

"This was not accidental,
 But designed by God and man,
A perfect combination,
 A horticultural plan."

Later as I watered plants,
 A wren scolded oh so loud,
Her precious babies silent,
 Hidden by a leafy shroud.

Daily wonders astonish,
 If we but open our eyes.
God's bounty for the senses
 Spring from earth, sea and sky.

What delights nourish our souls
 Those times we decide to pause.
Creation needs no defense,
 And beauty needs no cause.

Chickadees

A call comes from above,
 And with my ears I see,
The sweet song so nearby
 Is the cheerful Chickadee's.

Her call, same as her name,
 Tells us when she's around.
That "Chick-a-dee-dee-dee,"
 Her own distinctive sound.

The bird seems always young,
 A verbal, joyful sprite.
Flitting, chirping, playing,
 Silenced only by the night.

Bold chatterbox is she,
 Unafraid of us mere mortals.
Impertinent questions posed
 To those within her portals.

God's grace on the fifth day
 Created with His words
This gift for our senses—
 These sweet, delightful birds

Jays Are Welcome

This morning the birds were feeding,
 On a swath of new-cracked corn.
Three blue jays, with blue jay ways,
 Inciting both envy and scorn.

Uniform of glorious hues,
 And a handsome, striking crown
Adorn the blue jay artfully.
 How shocking, his raucous sound

I know humans shouldn't judge
 Those naughty habits of Jays,
We discount the gorgeous color,
 Naming instead his pesky ways.

When we remark how well designed,
 That his colors complement,
His rude ways are secondary,
 To the whole, it's just his bent

Critters of every kind are drawn
 To our daily feast of seeds.
We welcome everyone who comes,
 Even those of different creeds.

Duck Tricks

Every spring we welcome them,
 Tiny fluffs trailing Mom.
Bobbing beside nest-mates
 As Mama sails along.

Lots of plants and buggies grow
 In water, by the shore.
When they've eaten all in sight,
 Ducks will dip down for more.

Searching in the bottom growth
 With yellow, clacking bill,
His tail stuck up at half mast,
 A duck will eat his fill.

This distinctive trick is known,
 Among the ducky bunch,
As a bit of dabbling
 For breakfast or for lunch.

Dabble, waddle, paddle,
 Most any day you'll find
Busy here in grass or brook
 Ducks of various kinds.

So if you note half a duck,
 South end stuck up for awhile
Never fear, he'll soon tip up
 With his happy ducky smile.

Let The Daisies Grow

Loves me... Loves me not...
　　One by one they lay.
Grasp the petal-word
　　The last one will say.

Start afresh, ignore fate,
　　Disregard the fear.
This one will give me
　　Words I long to hear.

I have found love at last!
　　Let the daisies grow!
Jesus said He loves me,
　　All the petals know!

- John 3:16

43

Sing Mockingbird

Day and night Mr. Mockingbird
 Perches high, sings his heart out.
I do not see his lady love,
 But I am sure that she's about.

His repertoire is exhaustive,
 He never runs out of songs.
He keeps trying to impress her
 Singing loudly all day long.

I don't think he composes
 Many tunes in his collection.
He just borrows what he likes,
 Arranging them to perfection.

The content always surprises;
 Bird songs, voice of dog or cat,
Crickets, door creaks, car horns,
 Maybe even squeek of bat.

Something in his song attracts;
 Baby mockingbirds abound.
God is good, and so I pray
 They will always be around.

Big Fellow

They come to the suet regularly,
 Usually the male for a bite.
Impressive they are, color and size.
 The design seems to be just right.

The Indians had an ideal name,
 They called them Great God birds,
Pileated Woodpecker we say,
 Not the name of sacred words.

The bright red crest announces him,
 Swept aloft with wings black and white.
Black body, white stripes at his head
 Surely a bird both bold and bright.

His powerful large beak's a tool
 For finding squirmy, buggy food.
Wood chips heaping on the ground
 As he drills in rotten wood.

 He hammers like distant thunder,
 An eerie call as he dips and glides,
Telling us Great God's about.
 So glad in our woods he abides.

Leaves of Fall

Fall is such a rich, sweet time,
 Full of beauty, yet, faintly sad.
It's then I relive past days,
 Times both good and bad.

Today orange leaves and yellow
 Litter the cold dead ground,
The beautiful blossoms of autumn
 Lie bright and glad all around.

I'd not noticed until now,
 Prizes that had hung above,
Made a shining carpet below.
 Yet another sign of God's love!

In days those leaves will fade,
 Their rustle softened by rain.
In time they become rich mulch,
 And the cycle resumes again.

Welcome bright hues of autumn,
 Watch its colors fly away,
Find shards of color aground,
 Then await cold winter days.

Childhood Only for Children?

Grow Up?

If growing up means letting go
 Of catching fireflies that glow,
Why should I?

If I must learn to toil and cope,
 Give away my dreams and hope,
Why would I?

I don't want to spend my days
 Learning grown up words and ways.

If I can't laugh and sing and smile,
 I will forever be a child.

No listening for mockingbirds,
 The sweetest sound I've ever heard?

But, wait, past seventy and still,
 I do all these things at will.

We can grow up outside and be,
 A secret child inside, you see!

We must! Surely every one of us
 Can find their way, I trust.

Deep within my heart and mind
 That childlike happy faith I find.

Those dreams and hopes live, intact,
 Though grown up, I'm back!

Mother's Lament

I'll never yell at my children,
 I will take the time to play.
I'll listen with sweet pleasure,
 Hear prayers at end of the day.

Anger will never control me.
 I'll not say critical words.
Lavish encouragement and praise,
 By my family will be heard.

Mothers all over will tell you,
 Their solemn vows were the same,
To unborn children of promise,
 Their fulfillment—as sure as rain.

I hear my mother in my voice,
 And at last, I know her heart.
She made the very same promise,
 She struggled to do her part.

Mother's aims are universal,
 Because they all love their brood.
Adoring words and tender touch
 Are as necessary as food.

We will forgive our own mothers
 For failing to keep the vow.
We will learn the truth in our time—
 None of us really knows how.

Asking our heavenly Father
 To guide in the difficult way,
We try and fail, then do it right,
 As He gives us words to say.

Dancing in the Rain

Spring rain brings promises,
 Summer rain brings joy.
Watch what falling rain does
 To most any girl or boy.

Arms aloft, smiles raised,
 Dancing round and round,
Tasting stinging rain drops—
 Sweet music falling down.

Grown ups lose the wonder
 Of dancing in the rain.
We run to find shelter,
 Drying off, such a pain.

Crowned with loving kindness,
 Tender mercies abound,
Righteousness, peace and joy
 In the Spirit is found.

This is cause for dancing,
 Why do we stand so straight?
Why our hesitation?
 For what word do we wait?

Can't we come like children,
 Abandon fear and pride.
Worship with all our heart,
 Let the Spirit's joy abide.

 - Romans 14:17

Nana's Kitchen

"No, thank you," is sufficient,
 Really quite enough.
Don't want to hear another "Yuck!"
 Or, "That's disgusting stuff."

I understand that tastes are not
 The same for everyone.
Even I dislike some foods.
 (Liver was never fun.)

Keep it simple, just, "No thanks."
 It's OK if you refuse.
Comments rude about my food,
 And I really feel abused.

If you don't find what you like,
 There's one thing or another.
We keep a jar or two around
 Of jelly and peanut butter.

Playing House

We swept a square of woodland bare,
 Used cast off pans and dishes.
Pretended meals of leaves and seeds,
 Shared our dreams and wishes.

Paths and rooms were neatly scribed
 With rocks and wood and bricks.
It never crossed our happy minds
 That we were country hicks.

Wild, sweet blossoms growing near
 Brought fragrance to our place.
Soon we learned that there would be
 Chigger bites with Queen Anne's lace.

No *Easy Bake,* no porcelain dolls
 For kids in Canton Hollow.
We heard, "Make do with what you have,"
 A skill for years to follow.

If play required a hat or cape
 We gathered larger leaves.
Stitch with twigs, join one to one,
 Forget buttons and sleeves.

You two will be the children,
 And I will be the mother.
Nan will be the oldest child,
 And you will be her brother.

I am so sad that times have changed.
 Words no longer mean the same.
"Playing house" was childhood fun,
 Cause for neither guilt nor shame.

Nana's Advice

God gives us all wills and skills,
 He expects you to succeed.
Work hard for the life you choose,
 And you'll know joy indeed.

Don't see winning as beating.
 Finish every job with pride.
Take someone special with you;
 Lighten the load, ease the ride.

Do not abandon your dreams,
 Seek adventures through out life.
Temper senseless fear with reason.
 Be kind to husband or wife.

Grown older now, I look back.
 I didn't like to fail or lose,
So many things I didn't try.
 Don't let that fear hinder you.

We all learn bitter lessons,
 Some are harder than others.
I could save you lots of trouble,
 If you could hear grandmother.

Don't come to the days of limits,
 And sorrow for not having done
Things for which you always dreamed.
 Savor success you have won!

Favorite Child

I dearly love all my children,
 But when sadness covers a face,
I choose an appropriate time,
 And we find a secluded place.

"You, child, are my favorite one,"
 I whisper to each in their turn.
"You mustn't tell the others though,
 It would be hard for them to learn."

Sharing a secret or having a fight,
 The confidence just slips out.
"You know I'm her favorite one,"
 Is said with spite and a shout.

Mom in due course is forgiven,
 When all are done with their cry.
It doesn't take great wisdom
 To fathom the reason why.

She loves her children so dearly,
 That when sadness covers a face,
She charms a smile from that sad child,
 At a memorable time and place.

Nancy Herrett Lockwood

Summertime

In summertime we played outdoors
 Children of my neighborhood.
If it got too hot, we found a spot
 In grassy shade or cool, dark wood.

We played red rover, hide and seek,
 Exercised heart and limb.
We seldom called for mom if we
 Stubbed a toe or scraped a shin.

We played amid God's creation,
 Hats were stitched of leaf and twig.
We gathered flowers, sticks and stones—
 Nothing was too small or big.

To make a garland for our hair
 We made chains of sweet red clover.
Buttercups said we loved butter,
 Daisies, that we had a lover.

We numbered our future children
 Blowing dandelion seeds.
We saved lady bugs from danger,
 Saw just flowers, never weeds.

I wish that my grandchildren
 Could know such delightful days,
Summer times of great adventure—
 Finding joy in simple ways.

Come As a Child

I would return to childhood,
　　Delighted by all I find,
Awed by the senses' bounty,
　　Enchantments of every kind.

Tasting my first strawberry.
　　Smelling aromas of spring,
Wading in cold creek water,
　　Making memories that sing.

But these eyes have grown dim.
　　Have I lost the wonder words?
What day did I stop hearing
　　Melodies of wind and birds?

Many of us are blinded,
　　But not from the loss of sight.
We've let duty and worry
　　Steal every last ray of light.

Each good and each perfect gift,
　　Comes from our Father above.
So, look around and be glad
　　For the tokens of His love.

I'd be as a little child
　　Sitting there at Jesus' feet,
Savoring with every sense
　　This blessed life so sweet.

Family & Friends

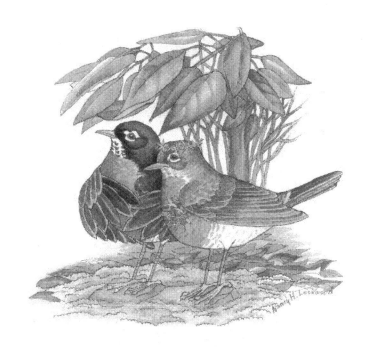

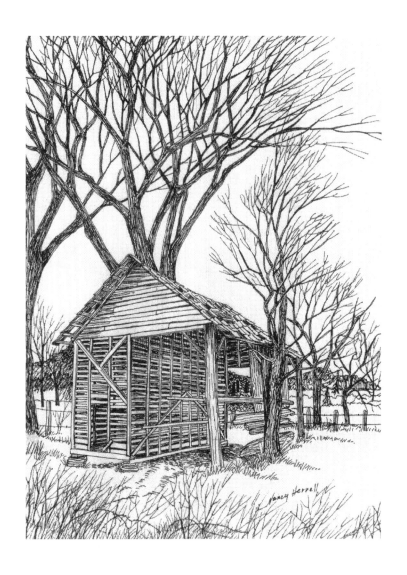

Papaw's Corncrib

We liked to shuck and shell corn,
 Great fun for a day or two.
Not much fun for our cousins
 Whose chores were never through.

Us city kids were cautious;
 Scared of rats, mice and snakes.
Watch for ones hiding in the crib;
 Be careful, each ear you take.

I hadn't noticed his fine skill,
 Not 'til I was full-grown.
For more than a century,
 Papaw's crib stood there alone.

Eighteen hundred, ninety-seven,
 The year he constructed it.
The work of one just nineteen,
 Built of oak, sturdy and fit.

Those of us who knew Papaw,
 Saw what craft was all about.
His fine workmanship, like him,
 Was of quality, no doubt.

At end of days what matters,
 Are the things we leave behind.
Do you share your values freely,
 Thoughts of your heart and mind?

Church Manners

We come here to worship God
 With a happy shining face.
This church is sanctuary,
 A loving, learning, safety place.

Names we use for each other
 Are those given at our birth.
Only labels that affirm,
 Never those that shame our worth.

Loving gestures often—
 No one kicks or hits or bites.
We smile and use good words,
 For we are gentle, we don't fight.

Respect expected and given
 To adult and friend and child.
That means quiet listening,
 Not as creatures of the wild.

Jesus knew and he taught it—
 Manners matter to us all.
Please, thank you, I am sorry,
 Helps each of us stand up tall.

The most sacred time for us—
 When we bow our heads to pray.
Time for quiet, time to listen,
 For what our Lord might say.

Asking him to hear our heart,
 Speaking joy, admitting sorrow
For a careless word or deed.
 Forgiven for tomorrow.

Please, Not My Sister

"She is dying of cancer!"
 Is not what I want to say.
I pray, "Sharon, be healed!"
 Maybe tomorrow's the day?

Years we waited for signs
 Of health and strength's return.
As her vitality ebbed,
 Hard questions seared and burned.

"Where's the relief she needs?"
 "Why hasn't Sharon been healed?"
"We have presented our prayers—
 When will heaven's grace yield?"

And then I looked on her face,
 And saw there within her eyes
God's grace had given her peace.
 She was set to sail the skies.

God's loving gift for that time,
 Days without physical pain.
Her focus upon the Father
 Showed her not loss, but gain.

When we pass through that valley
 We'll know the goals we pursue.
We can believe in His words.
 For the Savior's love is true!

I will always miss Sharon,
 The sister I love so dear.
Her trust was ever in Jesus,
 She gave Him all her fear."

 - 1 John 4:18

74

Remembering Bailey

Months into our married life,
　　Bailey came to live with us.
Though named and claimed by Tara,
　　Each us coddled and fussed.

The puppy charmed all of us,
　　The funniest dog I've known.
She gave treasured rocks to friends,
　　Even after she was grown.

During an outdoor sermon
　　Bailey awoke from a nap,
Grinned and dropped her rock du jour
　　In a listening lady's lap.

Banned from further services,
　　She never quite understood.
Didn't Jesus say giving
　　Was a loving thing and good?

One day while we were walking,
　　Bailey secure on a leash,
I saw the difference clearly,
　　What Jesus and Satan teach.

Satan's controls with tethers
　　If we're bound by his demands.
When we choose Jesus instead,
　　He severs all Satan's bands.

That He loves us, quite enough,
　　To keep us there by His side.
No need for shackles or chains;
　　In His love we safely abide.

Cat in a Lap

Clawdia, our cat, slept everywhere,
 But preferred a soft place for a nap.
On a bed or couch you might find her,
 But her favorite place was a lap.

The recliner belonged to the cat,
 Her place with no humans around.
If someone sat on Claudia's throne,
 She waited, and leapt with a bound.

You see, people were only pillows,
 Supplied for her personal pleasure,
So anyone seated and settled
 Was surreptitiously measured.

When Bob was stretched out and dozing,
 Claudia rushed into the room.
She leapt to her place, then settled,
 As she hummed her happiness tune.

Oh, how I envy the cat's courage.
 In a room filled with people and noise,
They will find the avowed cat hater,
 And inform them of their choice.

God knew we'd know that He loves us,
 When He sent this boon companion.
Just like Him, she longed to be close,
 And love us with joyous abandon.

Dudley Do Right

Dudley was our special pal
 Who happened to be canine.
He came as a small puppy,
 Mixed-breed of dirt and grime.

I named him prophetically
 Hoping he'd live up to it.
Although he didn't always,
 Dudley's name really fit.

Marked mostly black with tan,
 His eyes, the best part,
Bordered with blackest rings.
 He stole everyone's heart.

Unfortunately he was a thief.
 Whatever was left about
Careless neighbors just might lose.
 The culprit—there was no doubt.

Gloves and socks, his choice,
 A package of chili, a shoe,
Even an empty bottle or can,
 Most anything would do.

A half-full peanut butter jar
 Left for a minute or two,
Disappeared from a table,
 Dudley left not a clue.

Everyone loved Dudley,
 Forgave his thieving ways.
He entertained pets and kids,
 And enlivened old folk's days.

Dear Friend

We sisters console each other
 For what tragedy has wrought.
Struck dumb, not knowing how to live,
 Not yet returned to sentient thought.

Gone are thoughts of earned success
 In the midst of pain so raw.
My friend again recounts them for me,
 And heart and mind begin to thaw.

I grieve for those who have no friends
 With empathy as pure as mine.
Life would be so stark and empty
 Without this faithful, loving kind.

My Wise Mother

The longer I live, the more I know.
 When I remember what she said,
The smarter my mother grows.
 And then my face burns red.

When I was young, I knew it all.
 My parents were too passé.
As I approach their years of age,
 I appreciate more their ways.

When I finish a familiar chore,
 Done the way mother did,
Smiling, I say, too late for her ears,
 The "Thank you" that I hid.

I Wonder...

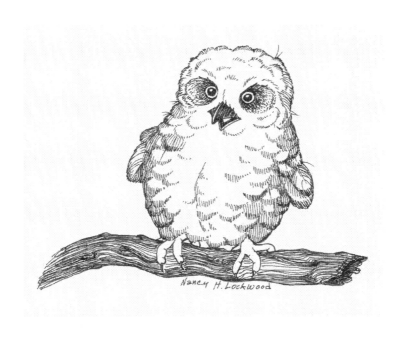

Nancy H. Lockwood

Little Brown Jugs

One day of my teenage years
 On an outing in the wood.
Daddy raised a heart-shaped leaf,
 As carefully as he could.

Under the leaf on the ground
 Were flowers without petals.
Tiny pottery sitting there,
 Undiscovered by most mortals.

Little Brown Jugs he called them,
 Known also as wild ginger.
Even now most folks don't know
 Of this woodland wonder.

Now we are living in the woods
 Where these plants grow wild
I enjoy introducing them,
 Especially to a child.

When my mother and daddy met
 He rarely would imbibe.
She said she would not drink,
 Nor become a drinker's bride.

I wonder if his interest in
 The brown jug of the woods
Held any memory of drink
 He would not take if he could.

Voracious Vine

This story begins when my daddy's pap
Chose the hammock for a summer nap.

Kudzu that grew half way up the trees,
By afternoon, wound way past his knees.

They twined onward, under and over,
Basket weaving, bottom and cover.

As day was waning, before twilight,
Pap was caught, trapped, wrapped tight

Supper bell tolled, woke Pap with a jerk,
He could not move, his limbs would not work.

Scared, he hollered; we ran to the sound,
Dad fetched the gun, whistled up the hound.

Dad's old pocket knife got our Pap out.
He danced and cried and gave a shout.

Remember this, when Kudzu's in view,
Nature can be unkind to me or you.

It will climb and hide all in its path.
In kudzu season, no vine is so fast.

Honey Moon

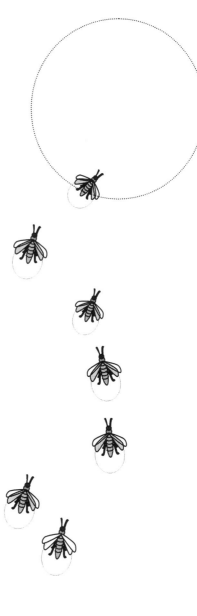

On moonlit summer evenings,
 Nocturnal folks come out.
We hear the choirs singing,
 We see them fly about.

As firefly season comes
 To our field and wood
An awesome sense of wonder
 Infects our neighborhood.

Most of us as children
 Chased them with a smile.
The magic remains with us,
 As the memory of a child.

Firefly boys go hunting,
 Searching as they roam,
For wingless lady glow worms*
 Who have to stay at home.

While searching for a mate
 Do the love-sick ever fall
For shining Mother Moon
 The night-light of us all?

*Only males have wings,
females are unable to fly.*

Morning Glory

Morning face opened,
 Followed the sun.
Closed-up forever
 As day was done.

One day to blossom,
 One day to shine.
What if only this
 One day were mine?

Today may be all
 The days I have left.
Maybe this moment
 Is my final breath.

The morning's been spent,
 Noonday's long gone.
Over my shoulder,
 Shadows grow long.

As time slips away
 One thing I know,
God still has a plan,
 I can still grow.

Rising each morning,
 Face to the Son,
Bloom where I'm planted,
 Til my work is done.

Spoons

I eat soup with a large spoon,
　　Dessert with one that's small.
Ice cream calls for a small spoon,
　　Teaspoon if the glass is tall.

Would I use a big spoon
　　To stir sugar in tea?
That would be uncivilized,
　　Much too uncouth for me.

Time for breakfast cereal,
　　I prefer a large spoon.
Unless we have soup for lunch,
　　Don't use large ones at noon.

Maybe it's food's soupiness
　　That needs a spoon that's big.
Surely no one thinks the size
　　Is standard for a pig.

Sitting on the Offense

Strays you don't intend to keep
 You should never feed.
Else you are responsible
 For their wants and needs.

Once you feed the wandering waif
 He becomes your charge.
Before your eyes he just grows.
 When did he get so large?

Offense, Offense, noisy pest,
 I should turn away.
Yet, I keep the dirty thing,
 Feed him day by day.

Answer quickly, cutting words;
 From a hateful thought.
Without will, they just pop out,
 Words that strife has bought.

I must quench the urge to voice
 Those hurtful, mean replies.
I pause and think of the cross,
 And offense within me dies.

I won't feed and stroke offense,
 Won't keep him at my place.
I'll listen for my Jesus' voice,
 Turn and seek HIS face.

-James 1:14-15

Sun-Works

Stately giants around our place
 Find changes in their trunks, long bare.
Those tall, lean expanses of bark
 Are sprouting new limbs there.

These trees are ones left to grow,
 Others felled to clear the way.
On the site of our new home,
 Our guardians, proud to stay.

Shaded well until the clearing,
 In the wood of close-grown trees,
Long years stretching for the sun.
 Top limbs bearing most the leaves.

Now freed from dark prison years,
 Something weird is happening.
Once bare-legged giants of the hills
 Are growing limbs like saplings.

Now the sun can touch the trunks
 Long denied warm ray's taste.
Seasons later we see the change,
 Like tutus around their waists.

Are we not reaching for the Son?
 Are some of us sin-prison bound?
And when we are freed from darkness,
 Folks see change and growth profound.

Winter Storm

Thunder crashing, lightning bright,
 Winds that howl and moan,
Fill us with delicious fright
 Though we're safe at home.

Claiming that we are cold,
 The fire draws us round.
Should the source of power fail,
 That is where light is found.

Fearful of various sounds
 We hear in dark of night,
Gives us ample cause to run,
 And speak aloud our fright.

Sheepishly, we own our dread,
 Admit assorted doubts,
And laugh at our childish fears
 Of what might be about.

No, we are not really scared,
 We shiver not from fear,
But cling to those who love us,
 And welcome drawing near.

Jesus stands there calling us,
 In all our frightful times.
His perfect love casts out fear,
 His grace—the tie that binds.

- 1 John 4:18

More Blessed?

"It is more blessed to give,"
 We are taught when we are small.
But none of us believed it,
 A tale that was way too tall.

We all like gifts at Christmas,
 And for birthdays once a year.
We have kept some of them safe
 Those tokens are very dear.

Givers are hooked on giving,
 Receiving is losing face.
Cheerful givers search for
 Those accepting with grace.

Not until we are mature
 Do we truly understand;
At times we need to receive—
 When we have nothing in hand.

If pride prompts us to avoid
 A person who gives in love,
We may forfeit a blessing,
 Possibly, gifts from above.

The Lord loves cheerful givers
 Paul said as plain as could be.
But there needs to be, also,
 Gracious receivers, you see.

 - 2 Corinthians 9:7

Hometown

I heard them talking quietly
 Of small town, hometown things.
I have no idea, I thought,
 Of what those words should mean.

No "Hometown" where I belong,
 Or friends held dear since school.
No other with whom to chat
 Of common, hometown rules.

We visited family often but,
 We moved around so much.
Made friends, then said goodbyes,
 Finally, losing touch.

Jesus helped me with each move,
 To make new memories.
He always came along,
 And with him, sweet peace,

"Hometown" I don't seem to need;
 I only sojourn here.
Did I heard my Jesus say,
 "Heaven's your hometown, dear."

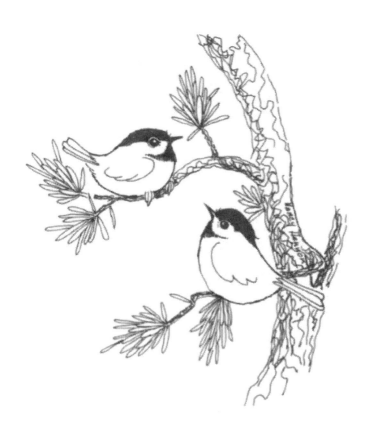

Hear Your Child

When you dream of the ideal man you should befriend or date
There are a few significant things for your mind to contemplate.

Is he cute with bulging muscles? Is his voice enticing to all?
Does he leave you weak in the knees? None good reasons to fall!

The questions you need to ask have little to do with right now.
Asking what's best will be too late once you've taken the vow.

Much better for you to consider are questions that look ahead.
Will this man care for our child? Not, how would he be in bed?

People are telling you how to live, especially mother and father.
Maybe you should take advice from your unborn son or daughter.

Imagine asking your young child to help you make your choice.
Hear the pleas of that future one, instead of your selfish voice.

"Choose a daddy for me, please, one who will love and protect.
Wise, understanding, patient; one who'll treat me with respect."

"Make sure he feels connected to and guided by God above,
That the Bible is his manual for learning the meaning of love."

We don't always know who to choose; we don't want to be wrong.
But those you KNOW to avoid, turn away, be wise, be strong.

Your antecedents will thank you, their lives will be better by far,
If your choice is a man of character, not one with a flashy car.

Wisdom in choosing a mate is needed before you start dating.
You want a good family life? That is worth prayerfully waiting.

Angels

It's the duty of angels, we're told,
 To minister to our care and needs.
Dispatched by God when we pray,
 To do their angelic deeds.

I'm not sure if I've seen one,
 I might have missed the event,
If an angel has crossed my path,
 I sure didn't see where he went.

A friend ministered as one
 When I needed her help most.
If I had to name someone,
 She would certainly come close.

I should value those around me.
 It's on my mind, in my prayer.
Lest I fail, and then find later,
 There had been angels right here.

Guardian angels protect us.
 We don't always see their acts.
Unseen are they on duty
 Deflecting our foe's attacks.

Since they halt what might have been,
 We only guess what they've done.
Continue to ask their assistance,
 Praise God for the battles they've won.

- Hebrews 13:2

I Am Worth More

During those uncertain years
 Hurt and mystified, I cried,
"What is wrong, what have I done?"
 "There is no one else," he lied.

A word or phrase can bring us back,
 I must find the one to say.
He loved me, I know he did.
 Please, Lord, show me the way.

Hope was never far away.
 Returns, I took for gains and wins.
Those were games he liked to play.
 Then he would be off again.

Only I could end the farce,
 I the umpire, called the game.
I reclaimed my own true self,
 Restored my own birth name.

Days that followed weren't always
 Filled with calm or confidence.
But our family of three learned
 A new interdependence.

Whether from his guilty shame
 Or some old list from the past,
A birthday gift from him arrived.
 "What a shock," I said, aghast!

Years later it came to me.
 Never meant to heal the rift,
It was, I think, the only,
 The first, throwing-away gift.

The Debate

There were three black buzzards
 Hunkered down on a rail,
Another on the ground,
 With a raggedy tail.

They sat there all morning,
 Eight keen, searching eyes,
Standing watch by the pond
 Hoping the dead would rise.

"Let's fly," said the first bird,
 "Circle and soar the sky."
"I'll not linger longer,
 If I don't eat, I'll die."

Eager as he could be,
 Hopping from side to side,
Bird number four concurred,
 "Come on, take off, let's ride."

"Wait, what's the big hurry?"
 Said buzzard number two.
"You think a meal will spoil,
 If we don't follow you?"

"What's that enticing smell
 Wafting across my nose?
Rabbit, squirrel or possum?
 Certainly not a rose."

Further discussion ended,
 They wouldn't debate more.
Their lunch at last was served;
 A carp was drifting to shore.

Found

Lessons of Faith

Lost and Found

We traveled steep and stony ground
Up to the mountain of Lost and Found.

Carrying sorrow and guilt and shame;
Some had hurts they'd never named.

We found sisters, young and old,
Some were timid, some were bold.

We cried and prayed and read the Word,
Listening for that we'd never heard.

Finally, surrendering familiar pain,
We lost so much, but what we gained!

We lost our burdens in that rocky place,
We found instead, peace and grace.

Up on the mountain of Lost and Found
We sang and danced on Holy Ground

Little Lamp

I watch that little flickering lamp
 Among those grown so dim,
And wonder if the Lord of lights
 Has brighter days for him.

He hasn't learned that sharing light
 Helps both of us to see,
That when I see his light come on,
 The flame grows strong in me.

As his beam flashes higher,
 I pray that he will thrive,
Ever growing, glowing brighter,
 A light that will survive.

Rejoice!

I thank you, Lord, for blessings,
 Praise you, in times of loss.
"Father, not my will, but yours,"
 Precious words, from the cross.

Past days longed for the present,
 Sorrows heal in Spirit rain.
I sing in the times of joy,
 Am formed in the womb of pain.

When prayers are met, praise Him,
 Thank God for all that life brings.
And when sadness attacks you,
 Rejoice till your spirit sings.

- Philippians 4:4

His Heart

Let the words of my mouth
 Be the words of my heart,
 And the words of my heart...

Be Yours.

Call for the Glory

Spirit contained within the skin,
 Resonating from my core,
I feel your glory poised and ready
 To answer my call for more.

Asking for wisdom and revelation
 Of what you require of me,
I go to the Word to seek your voice.
 I pray and fall to my knees.

Knowing the fear of losing the right
 To decisions that once were mine,
I yield to God control of my life
 Seeking wisdom of the Divine.

Repentance, not sorrow or shame,
 Must come, before His glory I see.
The blessing is stayed when I fail
 To heed God's own words for me.

I may not know full glory of God
 On earth, before heaven I reach.
But, as long as I live, I'll seek His face
 And listen for all He will teach.

Eden's Legacy

Incredible beauty, unbounded joy,
 Days in Eden, a constant delight.
Yet, the pair defied the one restriction.
 They lived among thorns after their flight.

Forever banished from days of Eden,
 Sorrow and toil ever a concern.
Created mortals' fall from perfection,
 Brought endless longing for a return.

Lucifer sent to ground for his role.
 Despised and shunned, he never forgot.
As the Messiah prepared for His cross,
 Ruler of hell shaped a brutal thought.

One of his minions fashioned a circle
 Of Adam's curse, thorns of the ground.
Crushed on the head of our Savior,
 Lucifer's revenge, a spiteful crown.

We know Christ died for all humanity.
 Suffering and death, sin's costly price.
Offspring of Adam regained his blessing,
 Jesus, paid our fare to paradise.

Answered Prayer?

Every day is not perfect,
　　Some moments engender fear.
But even in sad or fearful times
　　I know the Spirit is near.

There is no need to speak,
　　I simply pause for awhile.
"Please, show me what to do."
　　I close my eyes and smile.

The answer is never dramatic,
　　It is seldom what I expect,
But the source is ever certain,
　　I know the response is correct.

I leave the request in His hands.
　　On some later day I murmur,
As I receive the awaited gift,
　　"God sure has a sense of humor."

Somehow He makes sure that I know
　　A delivery either small or large,
Is just shy of the thing I asked,
　　And He is still the one in charge.

I am never disappointed because
　　I trust that He knows precisely
What He wants from His children
　　And His methods suit me nicely.

Win—Win

That "All things work together for good"
 Is not an easy thing to conceive,
But look at the larger picture, and
 It is quite possible to believe.

Don't concentrate on every detail;
 Each thing is not precisely the best.
Look at the whole, and then you will see,
 God was there with you during your quest.

I want to seek God's face each morning
 And when things don't go right I will ask,
"What am I to learn in this moment?
 Will you stay close during the task?"

From an unbeliever's perspective
 This is undoubtedly foolishness.
"You can not have it both ways," they say,
 "Both good and bad can not be blessed."

No matter what happens physically,
 I know deep in the core of my heart,
That my spirit shall live forever,
 Jesus has already done His part.

 - Romans 8:28

Lifestyle

It matters how I think—
 My thoughts affect my day.
Expect a day of good,
 And live a different way.

When things go wrong for me,
 I look for ways to cope.
Knowing God is with me,
 Gives me cause to hope

Should something really bad
 Come on my watch today,
I'll ask the Lord to help.
 "Show me another way."

"What am I to learn, Lord?"
 When trouble comes to stay.
I know I can trust Him,
 Each hour of each day

- Proverbs 3:5-6

Antidote

Should I come to a desert time,
 I won't linger there for long.
I'll bring my babies' smiles to mind.
 I'll play again in field and wood,
And follow where the brooks still wind.

When sorrow comes, I know it will,
 When I can't stem the flow of tears.
The Comforter whispers, peace, be still,
 Warms my heart and calms my fears,
And the Son will banish the chill.

Nancy Herrell Lockwood '98

Best Friend

I reached adulthood unscathed
 Few were the times I fell.
I maintained a low profile,
 Worked where I could excel.

On the subject of marriage,
 I wasn't careful enough.
Lessons were devastating,
 Some years were very tough.

The loss of a life-long dream,
 The worst pain of my life.
The role I loved, ended;
 Still mother, no longer wife.

To the questions that followed,
 I heard answered, so clear.
In my mind I heard Jesus,
 "I am your best friend, dear."

Friends may be less than perfect,
 A beloved may twist the facts.
Jesus' friends betrayed Him.
 I can bear any hurtful acts.

No longer am I cast off,
 I will never be alone.
Jesus said he'd be with me,
 He'd be my forever home.

- Matthew 28:20

Justice or Mercy?

Justice, justice, we loudly cry
 When tyrants and bullies rage.
Punish and destroy them, God.
 Lock them away in a cage.

But when we sin or fail our Lord,
 Our cries are another kind.
Mercy, not justice, is our desire.
 Repentance comes to mind.

Recalling the Lord's forgiveness
 When hurt and anger we face
Gives us the will to practice,
 Not justice, but mercy and grace.

- Colossians 3:13

I Come Around

Let Me be your priority,
 I want more time with you.
You've let things come between,
 Togetherness is overdue.

I come, I come, to worship You.
 I come, I come, it is overdue.
I come, I come, to lay it down.
 I come around.

Faith-Able

I judge myself a faithful woman
 As I scan the last sixty years.
I kept a record of the journey,
 More pages of faith, than fear.

I didn't name the serious doubts,
 The thoughts of helplessness.
I protected those I loved
 From the weight of my distress.

My parents never knew the scope,
 Of the threat of total blindness.
I always spoke with a positive voice,
 Deflecting my fear with kindness.

Once or twice when a crisis loomed,
 Frightened, I just forgot to pray.
But God heard the silent plea,
 And answered the unsaid, anyway.

Those verses of confident faith
 Are still my truest heart belief.
I trust God in the depth of my soul
 Amid doubt or fear, though brief.

I think God understands the times
 We revert to our own solutions.
He knew our selfish bent from the start,
 And seeks our focused attention.

Our Father forgives our missteps
 When we bring His words to mind,
And come to Him with wounded heart,
 Knowing compassion we'll find.

Eldest Child Syndrome

The loyal son and Martha
 Were cousins under the skin.
Both were consumed by anger
 At faults of their nearest kin.

Each was determined to do
 Those useful and proper things.
Elder siblings often carry
 The burden that status brings.

Combine privilege and duty,
 And you see the roles they shared.
Both pride and resentment felt.
 The trade off, they thought, was fair.

In essence, both of them said,
 "I'll not take it any more,
I am the one left toiling,
 What am I doing this for?"

Sharing both work and honor,
 Most times is better for all.
Martha could sit with Mary,
 Both sons could dance at the ball.

Balance was needed by each.
 Their anger might not have been.
If all had learned from Jesus,
 More love they'd have shown to kin.

- Luke 10:39-42; 15:25-32

Martha's Defender

I speak in defense of Martha,
 The sister from Bethany.
She and I have much in common;
 Her words often come from me.

I know the Lord rebuked Martha
 In a loving, careful way,
But I would have scolded Mary,
 Had many more words to say.

I know His words held good reason,
 But the chores had to be done.
Who did the cooking and serving?
 Mary sure wasn't the one.

The Word doesn't say that He did,
 But wouldn't it have been right,
If Jesus had just suggested,
 That everyone fast that night?

Still, Jesus had timeless reasons
 For saying each word, each phrase.
"Martha, I prize not the 'doing,'
 But times of worship and praise."

Am I filling my days with duty?
 No time to be quiet and still,
Unaware of the Spirit's voice,
 Unsure of my Father's will?

I'll try to be more like Mary;
 I'll slow my mind and my pace,
I'll learn at the feet of Jesus,
 To prefer not works, but His grace.

- Luke 10:38-42

The Imposter's Creed

I am proud of my kindness,
 I am glad that I am chaste.
I am good, I am faithful,
 Not a spendthrift, apt to waste.

Lifelong, kept the Commandments,
 Honored parents; word and deed.
I try each time to tell the truth,
 And I give to those in need.

Theft nor murder, are my sins.
 God's name is sacred to me,
Idols absent from my house,
 Often I am on my knees.

Yet in those quiet moments
 The questions come creeping in
Who is my example?
 And what am I calling sin?

"I am the righteous ideal,"
 Jesus declares in the night.
Pompous and boastful phrases
 Wither and die in His light.

Lord, keep us truly humble,
 Our focus always on You;
Heeding Your Word, Your Spirit,
 Until Your face is in view.

Mary Magdalene

Standing silent in the milling throng,
 He was circled about by the crowd.
"Pray won't you heal me." "Save me, Lord."
 Their sad, desperate cries rang aloud.

Inside those demons cried, "Jesus!"
 I felt each one trembling in fear.
"Quick, turn back, run fast," they implored.
 "We must get far away from here!"

An awesome force drew me onward,
 In spite of an ominous dread.
Engrossed in the work of healing,
 Our eyes met as he turned his head.

I felt a great longing within me,
 As he looked deep in my eyes.
What I'd always thought about loving
 Was suddenly ashes and lies.

Seven demons, cursing and writhing,
 Read my thoughts, and his intent.
The Master simply commanded,
 And, whimpering, all of them went.

From dark to light I ascended.
 Changed from the person I was.
When asked to explain the marvel—
 I know not why, I know the cause.

When I saw His face, I loved Him.
 When I knew His heart, then I learned,
God's love excels any human's,
 Forgiving, unending, unearned.

- Mark 16:9

124

Do I Speak Life?

Lord, I choose not to enumerate
 The failings of those in my space.
Numbering, instead, achievements,
 Watching for smiles to replace…

The sad, shameful countenances
 Of those souls longing to hear,
"You are my treasured loved one,
 I will protect you, never fear."

When I think that the lack of loving
 May drive those who choose to sin,
I want to point them to Jesus,
 Ushering His love-light within.

Show me how to do it, Lord.
 To love the unlovely the same
As you have chosen to love me,
 Regardless of my guilt and shame.

If they see God's love in us,
 If we see them as their best,
They may accept God's forgiveness,
 And His grace will do the rest.

Let the Psalmist's Shepherd lead us
 From the world of sin and strife.
Goodness and mercy will follow
 All the days of our lives.

- John 13:34-35

Am I Vigilant?

Is my manner vigilant,
 Knowing He will come for me?
Am I like Emmaus travelers,
 Who saw, but did not see?

Do I live with alertness,
 For His triumphant return?
Do I know without a doubt
 The truth of all I have learned?

Am I prayerfully learning
 The promises in His Word?
Or do I hesitate to share
 The messages I have heard?

The Bible tells me plainly
 To watch for the coming Lord.
Another reason to watch
 Is spoken of in the Word.

Be sober and vigilant
 We are given warnings dire,
Our enemy is watching
 To find more souls for the fire.

Since my trust is in Jesus,
 With Him I've taken my stand.
Satan hasn't the power
 To snatch me out of His hand.

I've chosen to follow Christ,
 So my purpose on earth below—
Share about Jesus and heaven
 Take others with me when I go.

- John 10:28; 1 Peter 5:8-9

Aging Gratefully

Nancy Herrell Lockwood '98

Who Am I?

"I am what I am," said Popeye,
 But that's not exactly a fact.
None of us are entirely us,
 We are so much more than that.

We are tiny bits and pieces
 Gleaned from the nature of others:
Friends, foes, those of our clan,
 Coworkers, fathers and mothers.

My eyes came from Daddy,
 I got my smile from Mother,
Creativity from both grandads,
 Humor from so many others.

Grandaddy's funny stories
 Taught me how to laugh.
Papaw's toys and furniture
 Led down creative paths.

The greatest gifts f rom my parents?
 What they taught about God.
They led by their example,
 Reading daily from the Word.

Lessons, words and deeds
 Molded the person I am,
There in the habits I've owned,
 All part of God's perfect plan.

The ever present teacher
 Played the biggest part,
With power to guide and change,
 God's Spirit within my heart.

Seasons of Life

Young people can't think of time
 As a metaphor of life's seasons.
Days of spring and summer are
 There to enjoy, no other reason.

Others feel the chill of autumn days
 Are sad portents of winter's arrival,
Reminders of their life's ebbing,
 The end of their earthly survival.

But I have a brighter, different take,
 Fall, the time to thoughtfully savor
Memories, surprises and delights
 Of life's sights and sounds and flavors.

Autumn has always been a time
 To celebrate nature's excess.
Gratitude in the autumn of life—
 My definition of sweet success.

Winter holds no sorrow for me,
 Nor do thoughts of my own death.
My autumn-life holds peace and joy,
 Then Jesus' face at winter's last breath.

First Grandchild

There is something so special
 About the very first one.
Candace, the first of many,
 Grandchildren, so much fun.

She was pampered and petted
 When she visited us here.
We played and read and swam,
 Wanting to keep her near.

Candace, was her own person,
 A clever and lovely child.
Mama's own little helper,
 She was never meek and mild.

A memory from long ago:
 In her gown, with matching toy,
Candace lying sound asleep,
 Her sweet smile a source of joy.

When I prayed for her future
 I asked our Lord to help and guide.
Teach her that even failures
 Show her where she should abide.

In her heavenly Father's care
 Learn His upright way to live.
There within His Holy Word
 Find blessings He has to give.

Living or Dying?

That certain age of reflection
 Appeared to me and friends of mine.
It was time of careful diet,
 The time of spoken dread and whine.

The focus was changed from living
 The days and hours as they come,
To the constant thought of dying—
 Watching sand in the hourglass run.

Even we who know the Lord
 Watch friends as they decline,
Feel changes in our own bodies,
 And mourn the passage of time.

The enemy would have us be
 Always focused on not dying.
He would take our eyes off Jesus
 With dreadful words, still lying.

The love of God is all around,
 Found in the Bible on each page.
Hear, "Perfect love casts out fear,"
 Apply to every time and age.

Find every day an adventure
 Determine to wake with a smile.
Each trial and challenge conquered,
 Finding Jesus there every mile.

 - 1 John 4:18

Never Too Old

We met when the two of us
 Thought love had passed us by,
But found with Christ, tri-unity,
 A oneness that will not die.

Giving up the nine to five,
 He offered to help me do
Chores I'd always called my own.
 He took on more than a few.

Since I always got up first,
 He said he would make the bed,
Layered high with ruffled shams
 And pillows piled on the spread.

How he made the bed so quick,
 Puzzled and astonished me.
Then I watched him late one night,
 And it was simple to see.

Tuck the spread round the pillows,
 And roll on down from the head.
Place the bundle at the foot;
 Unroll, next day, on the bed.

If it were done carefully,
 Reversed in a practiced way,
Little had to be straightened,
 The bed was made for the day.

This homemaker will tell you
 I have learned from my own spouse
Better ways of doing things
 After years of keeping house.

I Am Old!

I watch the young and lively,
> The fresh-faced lords of the earth,
And recall my own promise,
> Unaware of its true worth.

Each generation believes
> That theirs is one to find
The answers to life's questions,
> To fulfill the dreams of mind.

As I reflect on those days,
> On the wonders that are past,
I see life as a journey
> Which we travel much too fast.

Today I think and ponder,
> "How did I get to this place?
Who is she of the mirror,
> With wrinkles creasing her face?"

My mind still functions fully,
> I learn something new each day.
I do move somewhat slower,
> But, I can get out of the way.

Who has patience to listen
> To older women and men?
Those just a little younger,
> Soon to be where they've been.

Why does life's sequences find
> The end is not what we thought?
So we'd be ready for heaven
> The home that Jesus' blood bought!

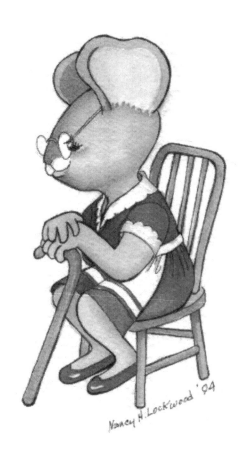

Synonyms

I thank God for synonyms,
 They've saved my reputation.
When a word abandons me,
 I can find a substitution.

If I pause and ruminate,
 Fishing for just the one,
No one knows the word escaped,
 And the game is almost fun.

I find my memory fickle,
 Most us old folks are aware.
We must feed vocabularies
 To avoid the old age snare.

I take a bit longer now
 To tell a favorite story,
You need to be patient though,
 It's best if I don't hurry.

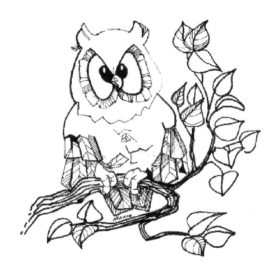

I Already Knew

I try to say a word or name,
 So frustrating not to recall.
The novel I read at forty,
 Today—not familiar at all.

It's a downside of growing old,
 Frustrating the slow, aging mind.
But there are yet compensations,
 Though details or facts I can't find.

My library could be reduced,
 Reshelf a book when I'm done.
Trying it in year or two,
 I'd discover a brand new one!

Reading the Word has always been
 For me a delightful pleasure.
I'm now finding brand new verses,
 Scripture divulging its treasure.

Now as I share a perception
 With the animation of youth,
I explain my new axiom,
 I comprehend a profound truth!

But I am not deceived for long,
 Recognizing it's not brand new.
I do enjoy the sensation—
 Learning again what I already knew.

Courageous Hearts

We who "Give our hearts away"
 Often find when love has gone,
That some of which we gave up
 Did not find its way back home.

Take care that you do not give
 So much of your only heart
That you haven't enough left
 Of the core, the loving part.

Before I had relearned to trust—
 Having been so well betrayed,
I met a kind and godly man,
 One who was not prone to stray.

Unfortunately, I had not yet
 An intact heart to give to him,
My best love and understanding,
 My heart filled up to the brim.

There was still a caring heart;
 Tempered well by joy and pain.
Although still scarred and sore,
 At last, it found its beat again.

After thirty years together,
 And all our five chicks agree.
This marriage has truly been,
 The best match for Bob and me.

Gardening

Don't forget, water the flowers.
 Remember to pull the weeds.
Beauty rewards the hours
 You water and weed and feed.

More precious to God than flowers
 Are people who live and grow.
Shouldn't we water, weed and feed,
 Sharing the Word that we know?

Water loving encouragement,
 Choke weeds with the Holy Word,
Then Christ's salvation can nourish
 The heart that listened and heard.

- 1 Corinthians 3:6-9

Christmas Bonus

As I hang old ornaments,
 Times and faces come to mind.
The bells my two assembled,
 Are the most treasured kind.

Rudolph made of sticks and yarn,
 Unicorn from days long past,
A framed cross-stitched circle,
 Are a few that bind me fast.

Those made by sons and daughters,
 Ones from grandchildren dear,
Reminders of ones long gone,
 Take me back to yesteryear.

Take them from their boxes, then,
 Put them away 'til next year,
Remember with family and friends,
 And share a smile or a tear.

Our tree isn't very elegant
 By standards of current style.
But our tree is filled with love,
 Once again I feel like a child.

When the Time Comes

Will we remember when we are old
 How we treated the aged and fey?
Will the words we used then
 Return to us some distant day?

My parents became as they aged
 Confused and difficult at times.
I was impatient more than once.
 I am ashamed of those crimes.

Yes, it was long days of work and care,
 So very little time to myself.
The changes for them were greater,
 Losing home and friends and health.

Looking back, I cherish sweet moments
 At the end of their fruitful days.
They knew, in spite of the bumps,
 That I treasured their faithful ways.

I had the privilege of witnessing
 Their thankful words and final breaths.
Daddy's acceptance of other's care,
 And Mother's loving touch as she left.

These days I wonder what life will bring
 When I need the same kind of care.
Will my children consider the toil
 Too heavy a load for them to bear?

Will I think, when it is not pleasant,
 That pay-back is well deserved?
Or, will God's grace on that day
 Find dignity and love preserved?

Home

Warm, safe, comfortable, a place deep in the pockets of my mind. I have been searching for this home most of my life. There were times when I thought I had found that haven with another, but eventually, I'd not feel safe, nor cherished, and knew I was not there.

Most of us yearn to be protected and nurtured, to have all our needs met, to go even farther back to the prenatal consciousness of safety and comfort.

I no longer believe that someone else can give me this feeling of absolute security. The answers can not be found in another human. God's Spirit in us, is what we need to find all that we can be.

No other person can sustain the illusion for long. The only true answer is in the One who never fails us, as humans must do.

Finally, I am home. God is, and I am His!

The Critters have entertained children of all ages. This story appeared in *The Cumberland Presbyterian* as a tale for adults.

Maggie The Samaritan

The place had a feeling of decay about it, an unloved house. Dust balls scudded across the wooden floor with the slightest movement of air. Stacks of unwashed dishes cluttered the table. Annie sat slumped in her rocking chair staring, but unseeing. Jumbled thoughts reeled through her head, fantasies bounced off fears and feelings with no pattern or purpose. An occasional

happy memory intruded, but mostly there were sad pictures of what she imagined lay in her future. Random tears dripped off Annie's chin and almost inaudible sighs escaped. This had been Annie's world for the weeks since her surgery. Permanent restrictions imposed by her doctor had robbed Annie of the job she loved and many active pleasures. Depression, growing like a malignancy, threatened to consume what had been a vibrant, happy, active woman. That's how Maggie found her.

Stumping through the door like a wagon with a broken wheel, Maggie stuck her cane within inches of Annie's face . "Do you want to get rid of me too?" she sputtered angrily.

Annie moved to dodge the old woman's jabbing cane, "No, no, Maggie," she pleaded. "Please, sit down and tell me why you're so angry."

Maggie shook her head, spent by the heated outburst, "Child, why are you hiding away?"

"Oh, Maggie, I feel so useless," sobbed Annie.

The wise old woman sat quietly and waited until the crying had subsided to sniffs and hiccups. Taking Annie's hand, Maggie asked a simple question, "Do you think I am useless?"

"Of course not! Why would you say such a thing?"

Maggie continued, "I've had to depend on someone else for transportation for years. I need help with my housework. I don't have a job, my church work is limited. Should I hide away and stop living, stop doing even the tasks I can? It pains me to see you wasting your life—grieving over the past and agonizing over possible future disappointment or pain. You are a young woman with many useful years ahead of you."

"I am just not used to being dependent on anyone but myself," Annie wailed. "I put on my first apron when I was four. It hurts to think of not being able to do the things I enjoy, especially my job. Even the things I can do fill me with the fear of doing even more damage and becoming more helpless. How can I feel anything but worthless? Even my memory of Bible verses and hymns are no help. I can only think of those to do with work and giving. 'He who will not work will not eat.' 'It is more blessed to give than to receive.' 'Work for the Night is Coming.' 'Make Me a Blessing.' Now where does that leave me?" said Annie with a shrug.

"It sounds like you have heard too much about 'doing' and not enough about 'being,'" replied Maggie. "The Lord himself told us what was most important, 'Love the Lord your God with all your heart... and your neighbor as yourself'" (Luke 10:29).

"That verse from Micah 6:8 helped me," Maggie added. "'He has shown you, O man, what is good; and what does the Lord require of you but to do justly, to love mercy, and to walk humbly with your God?' We can at the very least, love our neighbor, do the right thing, be merciful, and walk with the Lord, can't we? Surely you know that we are much more than what we do."

Annie's restlessness was increasing with Maggie's words. "But what about the satisfaction that comes from being able to do for others and earn your own way? It really is 'more blessed to give than to receive.'"

Maggie was no longer smiling, "Yes, the result of giving is a great feeling, but you are being awfully selfish wanting to keep the blessings for yourself."

147

Annie jumped as if she'd been shot, "No one has ever accused me of being selfish. I have always done my share, and more. It is horrible of you to say such a thing now that I can't do all I want. These thoughts keep running through my mind about what I've lost and how limited I am. I feel like everyone, as well as God, is disappointed in me," said Annie. And the quiet tears began flowing again

"Well," said an indignant Maggie as she stuck out her chin, "you can be sure those ugly thoughts are not coming from God. God does not want you to feel defeated and separated from him. He loves you more than you love yourself. God made you in his image. You need to be listening to 'The Comforter' Jesus promised us. You need comforting, right? So go the Source: the Word and the Throne. Have you been reading your Bible and praying about this?"

The tears flowed faster, "No," whispered Annie, "after all my years as a believer I just thought of all I had lost and forgot all that I had learned. Anger and depression were my only companions."

Annie wiped her face, stood and looked about the room, suddenly embarrassed at the disarray and dust. She picked up her apron with a shake and a smile. "I think I could teach someone else to do my job and choose another one that I could handle easily."

Maggie let out the breath she had been holding so long and crushed Annie in a big hug.

He has shown you, O man, what is good; and what does the Lord require of you but to do justly, to love mercy, and to walk humbly with your God.

- Micah 6:8

148

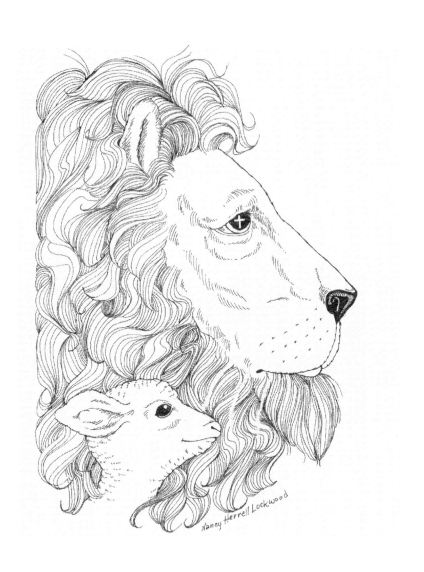

Nancy Herrell Lockwood

150

The Lion – The Lamb

Although scripture does not say: *"The Lion shall lie down with the Lamb,"* many images of the two have been created in this mistaken belief. The scripture does say instead, in Isaiah 11:16, *"The wolf also shall dwell with the lamb... the calf and the young lion and the fatling together..."*

The Lion of Judah and the Lamb of God are symbols of Jesus found in many places in the Bible, including the fifth chapter of the book of Revelation. His eye shows the strong lion's awareness of His destiny as the King of Kings, the Lamb is the willing sacrifice for humanity.

Praise God for the great gift of His Son!

About the Author

Nancy Herrell Lockwood, a native of Knox County, Tennessee, has been drawing and painting most of her life, learning mostly by doing. She completed one year as an art major at the University of Tennessee.

These poems and stories, written and illustrated during fifty years, represent a lifetime of wonder at the Creator's handiwork. The Li'l Critters are, Nancy says, "children in disguise. She observes and asks questions about nature, faith, being part of a family and growing older with awe and often, humor.

During his work with small Tennessee churches her husband Bob encouraged Nancy to create and present children's sermons for their congregations. Those mini sermons are now being used in a daycare facility.

Nancy and Bob have five grown children from previous marriages, eight grandchildren and two great grandchildren. They enjoy working on their "Sanctuary" in the woods, reading, writing and volunteering at a local healthcare facility.

8558179R0

Made in the USA
Charleston, SC
21 June 2011